John Boardman (b. 1927) grew up in Essex during the Second World War and won a scholarship to study Classics at Magdalene College, Cambridge. Early in his career he spent time in Greece, serving as assistant director of the British School of Archaeology at Athens and excavating in Smyrna, Crete and Chios, before returning to the UK to work as an assistant keeper at the Ashmolean Museum. In 1959 he became a reader in Classical Archaeology and fellow of Merton College, Oxford. He is now the Lincoln Professor Emeritus of Classical Archaeology and Art in Oxford. He was awarded a knighthood in 1989, the British Academy's Kenyon Medal in 1995 and the Onassis Prize for Humanities in 2009, and has written extensively on the art and archaeology of Ancient Greece. His many publications for Thames & Hudson span a period of more than six decades.

POCKET PERSPECTIVES

Surprising, questioning, challenging, enriching: the Pocket Perspectives series presents timeless works by writers and thinkers who have shaped the conversation across the arts, visual culture and history. Celebrating the undiminished vitality of their ideas today, these covetable and collectable books embody the best of Thames & Hudson.

JOHN BOARDMAN
ON THE PARTHENON

With 15 illustrations

This book consists of extracts from *The Parthenon and its Sculptures* by John Boardman and David Finn, published by Thames & Hudson in 1985.

Front cover: Detail of Frederic Edwin Church, *Columns of the Parthenon, Athens*, 1869. Brush and oil, graphite on green cardboard, 50.5 × 30.6 cm (19⅞ × 12⅛ in.). Cooper Hewitt, Smithsonian Design Museum Collection. Gift of Louis P. Church. *Endpapers:* Detail of Frederic Edwin Church, *The Parthenon*, 1871. Oil on canvas, 113 × 184.5 cm (44½ × 72⅝ in.). The Metropolitan Museum of Art. Bequest of Maria DeWitt Jesup, from the collection of her husband, Morris K. Jesup, 1914

First published in the United Kingdom in 1985 in *The Parthenon and its Sculptures* by Thames & Hudson Ltd, 181A High Holborn, London WC1V 7QX

First published in the United States of America in 1985 in *The Parthenon and its Sculptures* by the University of Texas Press, Austin

This abridged edition published in the United Kingdom in 2024 by Thames & Hudson Ltd, 181A High Holborn, London WC1V 7QX

This abridged edition published in the United States of America in 2024 by by Thames & Hudson Inc., 500 Fifth Avenue, New York, New York 10110

John Boardman on The Parthenon
© 2024 Thames & Hudson Ltd, London
Text © 1985 John Boardman

British Library Cataloguing-in-Publication Data
A catalogue record for this book is available from the British Library

Library of Congress Control Number 2023952403

ISBN 978-0-500-02726-4

Printed in China by Shenzhen Reliance Printing Co. Ltd

CONTENTS

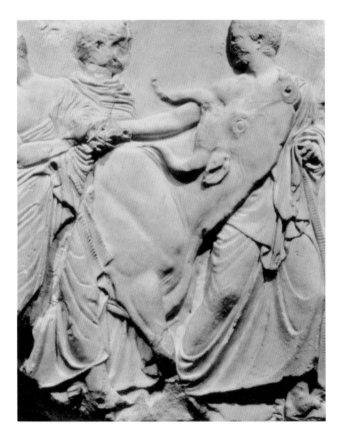

1. Attendants with cows for sacrifice
(slab xl) in the south frieze.

PREFACE

TIME AND CHANCE have determined that the Parthenon and its sculptures are the most fully known, if least well understood, of all the monuments of Classical antiquity that have survived. Our view of Classical Greece is conditioned by them, unless we think to prize its literature more than all other manifestations of the culture that produced it. The architecture and the sculpture are the best, of their type, that we have, and very probably the best that were created, but this is art history, and a descriptive account of them would be a mere formality which easily disguises what more there is to understand. There are several different ways of approaching such fuller understanding for any observer who has not the time or taste for the minutiae of scholarship. In a way the story of the Parthenon begins with the arrival of Greeks in Greece, with the Greek land itself. It embraces the beginnings of organized religious life in Greece and of Greek religion (not the same thing); the absorption into Greek life and thought of foreign ideas and arts; the history of architecture and sculpture; the development of the narrative

Overleaf 2. The Parthenon from the north-west.

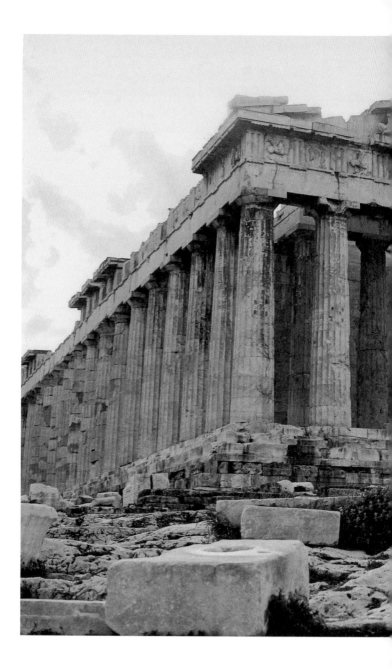

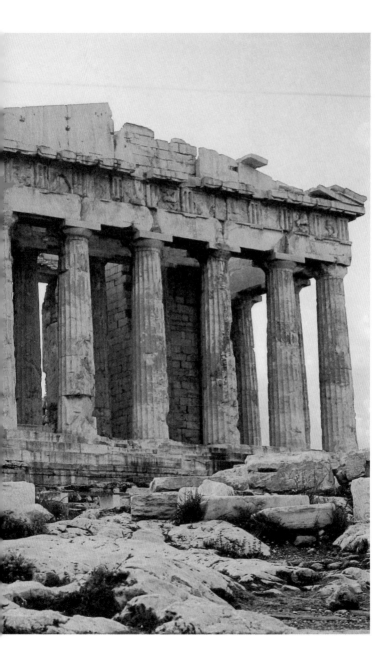

and symbolic functions of myth; the physical, political, economic, social and military history of Athens itself.

Our evidence is so incomplete, and we stand at so great a remove in time and temperament from Athens of twenty-five centuries ago, that an honest account has to be hedged about with caution, alternatives explored, doubts expressed, ignorance unashamedly paraded.

My narrative is disposed round five celebrations of the Great Panathenaic festival, which plays an important part in the Parthenon's history, figures in its sculptural decoration, and was the occasion of its dedication. The *celebration* in what we call 490 BC, less than six weeks before the Athenians defeated the Persians on the plain at Marathon, introduces those characteristics of the festival which help explain the Parthenon frieze, in a historical setting which will also be found to explain the purpose of the building. The festival of 478 BC, after the *destruction* of Athens by the Persians, took place with Athens and the Greeks ultimately triumphant and devoted now, through the Athenian League, to the expulsion of the barbarians from all Greek lands. By 450 BC that aim had been achieved and Athens was turning her attention and resources to the rebuilding of her city and the *conception* of a new temple for her city goddess, which would honour both her and her city's achievement. Eight years later, in 442 BC, the workshops and masons' yards were busy in the *creation* of the subtlest of all Greek buildings and the carving of sculptures which would typify the essence of the Classical ideal in its depiction of the human and the divine. Finally, in 438 BC,

comes the *completion* and dedication of the building, and a description which demonstrates how Athens' role at Marathon and in the defeat of the Persians, and the conduct of her Great Panathenaic festival, can explain the symbolism and narrative of the great sculptures.

THE STORY OF THE PARTHENON

CELEBRATION

ATHENS, HIGH SUMMER; the last days of the month Hekatombaion, in the archonship of Phainippos, the third year of the seventy-second Olympiad; the anniversary of the birthday of the city goddess.

Athena had sprung fully armed from the head of her father Zeus, a miraculous birth acclaimed by her Olympian kin, and an occasion of alarm only for the smith-god Hephaistos whose axe had cleft Zeus' head to release the newborn. Her armour and weapons proclaimed her a warrior goddess, but when she came to struggle with Poseidon for control of the city of Athens and its countryside she succeeded through her gifts of peace – crafts and the olive tree. Poseidon had threatened to flood their land, and this was the first occasion on which the citizens of Athens had found salvation in their goddess. Now they were gathering to celebrate the festival designed to thank her for favours received and to guarantee favours to come.

The celebration of these 'Panathenaea' occurred annually but every fourth year there was a special festival of thanksgiving, the 'Great Panathenaea', and this was such a year. Its high point was the procession which escorted to Athena's temple on the Acropolis

the newly made *peplos* robe, to be wrapped around her sacred olive-wood image. There would be prayers, hymns, sacrifice of cattle, feasts. But there were games too, athletics to match the contests at Olympia, musical competitions, a torch race, events to occupy the eyes, ears, imagination and belly for several days.

The procession was assembling around the north-western gate of the city, where the road ran out through the cemetery towards the hills in the west and, beyond them, to Eleusis and the goddess Demeter's Hall of Mysteries. There was little room to manoeuvre within the walls for the mêlée of brown bodies; the older men had wrapped themselves in a light cloak, but the hoplite soldiers were reluctant to encase themselves too soon in bronze and leather, though the sun was still low and not yet scorching. The young riders calmed their fretting horses, women gathered to serve the procession and rites along the way, and, waiting beyond the walls, there were the cattle for sacrifice. Priests, magistrates and marshals sought to impose order on the apparent chaos, to observe the due process of a festival which, in this form, had been inaugurated less than a hundred years ago but which had acquired new offices to perform and which had a new civic conscience to express.

The walk to the Acropolis was less than two thousand paces, but today hours would pass between the procession's first move into the open market-place towards the lower slopes of the Acropolis, and arrival on its summit with the burden of offering and sacrifice. There was much to do along the way, rites to perform, visits to be paid

to shrines and altars, ceremonies which equipped the procession for its sacred task, displays of martial and cavalier skills. But this was no military parade: elders and citizens walked the Panathenaic Way, as well as troops of soldiers, cavalry and clattering chariots, and citizens viewed its progress and ceremonies. There was no real distinction between participants and viewers in the city's celebration of itself and of its divine patron.

Groups were beginning to form, with their gear, to take their place at the head of the procession where the priests and magistrates had gathered: elders carrying branches of Athena's sacred olive – her tree on the Acropolis would soon be heavy with fruit, and the sacred groves had, since the last Great Panathenaea, yielded their harvest of oil to reward success in the Games; girls with baskets laden with the sacrificial knives and the barley to be thrown over the victims; girls with stools and parasols to serve the comfort of their betters at the ceremonies along the way; girls with water jars, the daughters of *metoikoi*, the non-citizen residents who were allowed a place in the civic event, with their brothers carrying trays of offerings on their shoulders.

There was no signal for the start of the procession, hardly more than a general agreement that the dignitaries should move towards the market-place and the crucial opening ceremonies. The occasion had the informality of a family gathering but its purpose was a serious one. Only formal observation of the rites could ensure success, and Athens could not afford the wrath of a jealous or disappointed goddess. By visiting her annually in this way,

and by their regular gift of a new robe for her statue, her favour and their security were renewed and guaranteed.

From within the city gate the Panathenaic Way led to the corner of the market-place, the Agora – a place of assembly as much as of trade, where the citizens were summoned for matters both of state and of entertainment. On the right, just before the road entered the open space, stood the Royal Stoa, a little colonnaded building in front of which were displayed Athens' first written laws and where the Royal Archon, who had control of the religious life of the city, had his offices. In a workshop close by, in the quarter where potters' kilns and smithies lent more than their fair share of noise and dirt to the air of Athens on working days, a group of women were folding the new *peplos* for Athena on which they had been busy for the past nine months: a woollen robe, fit for a goddess, woven with scenes of the gods battling with giants, Athena herself prominent in the struggle beside her father Zeus. The sacred loom had been dismantled to await its next service in four years' time, but its heavy bronze legs were displayed at the door and the robe was received by two of the *arrhephoroi*, the young girls who lived on the Acropolis to serve the goddess. It had been their duty to initiate the making of the new *peplos*, though the weaving was left to stronger and more experienced hands, and it was their duty to deliver the finished robe to the Archon who stood before the Royal Stoa with the priestess of Athena to receive and inspect it.

There would be many more such stops on the processional way. Stools were carried for the leading officials

and the priestess so that they should not be too weary for their tasks at Athena's temple. The rest of the crowd, denied any clear view of the rites, were more patient at these early ceremonies than at later ones, and some were already moving forward to vantage points for viewing the more active events to come.

Once the robe was accepted there followed visits and offerings to nearby altars: first, to the tribal heroes. Barely a generation ago the city had shaken off the rule of a tyrant family, which had been beneficent enough in its early years of power but which eventually succumbed to the pressure of exiled families and Spartan arms. In a new constitution whereby the government of the people was more clearly laid in the hands of the people themselves, the four old tribes of Athens were replaced by ten new ones, their members territorially distributed through Athens and its countryside. By these ten tribes Athens' army was now marshalled, and their representatives were ready for the procession, in distinct troops. And for the ten tribes ten heroes and kings of Athens' past were chosen, to give their names and in spirit lead the citizens in war or peace. These, the Eponymous Heroes, were worshipped on the other side of the Panathenaic Way, and after due gifts and prayers were offered to them the Archon and his party returned to the road, and to another altar beside it, where the Olympian family was worshipped. Athena was the city's goddess, but the family of gods, for whom the poets had fashioned genealogies and stories, had here, for the first time by Greeks, been given a religious status and a focus for worship which transcended their individual

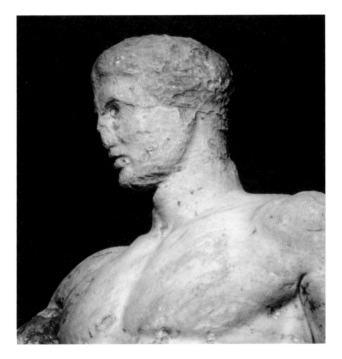

3. Head of Dionysos in the east pediment.

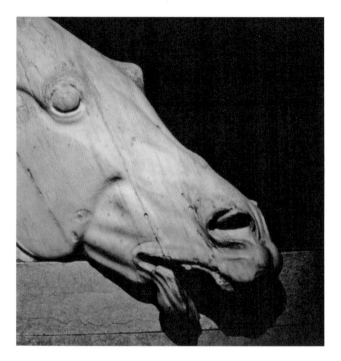

4. Horse from Selene's chariot
in the east pediment.

functions or their significance to different localities or professions in Athens and Attica.

The gods of the Greeks and the heroes of Athens' tribes were not the only supernatural presences whose attention had to be sought along the Panathenaic Way. Within the market-place, when it had been cleared for assemblies some hundred years before, old graves had been found, perhaps of Athenians who had fought and died for the city many years before, some of them even from families who remembered their names and deeds with reverence. A disturbed grave cannot be ignored; the dead have their due, and the long dead, even the nameless, demand the attention of the living. Horses and chariots were prominent features in the cult of the heroized dead, and contests of strength and skill accompanied the rites of remembrance as they had of burial. In Athens displays of riding and of chariots in the market-place had celebrated them, and the displays had been incorporated in the Panathenaic procession, along the flat straight road, called the *dromos* – 'race course' – where it crossed the open space ending in a gentle rise towards the Acropolis and beside the hill of Ares.

The riders paraded in their troops, by tribes; they dashed and wheeled along the road. It was not so much a race as a display of cavalier skills. In Athens' army the cavalry was relatively unimportant and victories were won through the steady discipline of the ranks of heavy-armed soldiers – the hoplites with their bronze armour and long thrusting spears. The soldiers were in the procession too, but for the moment attention was held by the horsemen.

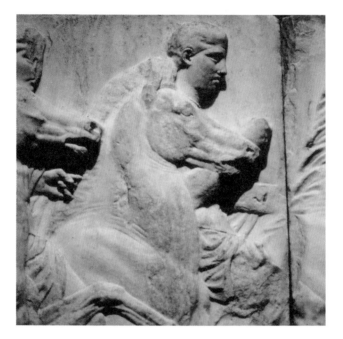

5. Horsemen (slab x)
in the south frieze.

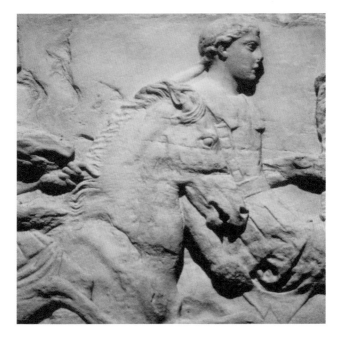

6. Horsemen (slab XIII)
in the south frieze.

Possession of a horse or horses had long been a symbol of status, and the symbolism extended to the world of the heroized dead in their cavalier Elysium. Chariots were an even more emphatic indication of status. In the age of heroes chariots ruled the battlefield. The Athenians knew their Homer and his poems were recited at the festival, so the heroic connotations of chariots in the Panathenaic procession were the more apparent. At Troy, it seems, chariots carried heroes from duel to duel, but the massed charge, as on the plains of Asia or Egypt, had in fact been the commoner practice, and one not altogether forgotten beyond the Greek world. In Athens chariot-teams were trained for races at the Games, and they appeared on some civic and private occasions, bestowing special honour on their riders. On the Panathenaic Way they offered the grandest spectacle. A soldier stood beside each charioteer, and as the team galloped he leapt on and off the car, stumbling to keep his balance and his grasp of shield and spear, then racing to seize the wooden chariot rails and haul himself again on to the bucking car. The crowd cheered the agile, hooted the clumsy, and thoughts of worship or sacrifice might seem far from their minds. But the chariot display was meaningless as a military exercise, and the young men, bruised and dirty from the chase, were cheered as surrogates for those Athenians who had died as heroes, and would die in days to come, in defence of their homeland.

The rites performed, the dust settling after the displays of horses and chariots, the main body of the procession moved on out of the market-place towards the Acropolis.

Carts and chariots were abandoned as the path grew steeper and rockier, and the cattle jostled and nudged their way up the difficult slope, through the small colonnaded gateway, past the great walls of unhewn boulders (built by giants, it was said) on to the Acropolis top, to the Temple of Athena and her altar. The temple was an old building, but refurbished by the new democratic regime of Athens, and its gables were now graced by marble groups: at one end symbols of supernatural power, lions tearing a bull – at the other, gods fighting giants, the theme of Athena's *peplos*. The olive-wood statue of the goddess, quaint, stiffly old-fashioned, almost foreign in appearance, had been decked in gold and jewelry. The new robe was brought forward and wrapped around the figure. In a moment it was translated from an inert to a living majesty. The Athenians' goddess was with them, her blessings renewed as visibly as her servants had restored her image to its deserved splendour and dignity. Hymns praised her strength and beneficence, and recalled the old kings and heroes of Athens who had taught the city how to worship her and secure her favour. But there was an even more direct means of communication with her, the sacrifice of a hundred cows, and the bellowing of the frightened beasts signalled the start of the last, most important, and bloody, act of worship on that holy day.

Years ago, when men talked with gods, Prometheus had tricked Zeus into agreeing that the gods' portion of a sacrificed animal should be its bones and offal, wrapped in rich but unappetizing fat, while the lean meat was left for mortals. In this way a conspicuous display of offering

for the gods – the fat burnt well and smokily – was combined with a feast for worshippers, for many of whom a meat meal was something of a luxury. Athena's altar was a long, low platform. Fire had been kindled on it already from a torch carried in a race of youths from the Academy, a mile beyond the city gates. One by one now the beasts were dragged before the altar, the stunning axe rose and fell, the knives lost their lustre beneath a coat of fat and blood. The rock was slippery with blood, the air heavy with the smell of guts and sweat. The slaughter bred excitement, shouting anticipation of the feasts to come, while the black smoke rolled thick and heavy up into the still and shimmering air, a clear signal to Athena that her citizens had paid their due respect. That smoke would rise for hours to come, while the lean meat – and there was not that much, even on a hundred of Athena's chosen cows – was dragged and carted down to the market-place for distribution. Other fires would be kindled in the city that night, and new wine jars broached, with other prayers for the goddess, her city and the homes of her people.

The festival of the Panathenaea was the main religious event of the year for the Athenians; the Great Panathenaea, when its year came round, especially so. This year the procession and sacrifices had been as others had been, and would be again, but the Athenians who made their way down to the city, refreshed with their acts of worship and dedication, had more on their minds than the feasting yet to come. To explain why we must go back to events of nine years before, events in which many of the celebrants had taken part.

The Athenians were Ionians by race, and their kin in Greece lived mainly in the islands or on the far side of the Aegean Sea, to the east, on the coast and offshore islands of Asia. The Aegean was a Greek sea and communications were hardly more difficult or time-consuming than journeys across the mountain-strewn mainland. But the eastern Ionians had fallen on hard times. The Empire of Persia had spread explosively through the lands of the east, to the Indus, into Egypt, and now on to the coast of the Aegean where many Greek cities had fallen to the easterners or were in the control of Persian-appointed governors, paying tribute to the local capital of the province, Sardis, former home of the philhellene Lydian king, Croesus. Now the Ionians had appealed to Athens to help them throw off the Persians, and the city had responded by sending a substantial part of her available fleet and men. The distances seemed enormous, the prize remote, but the appeal, which other Greeks had turned aside, found a response in the confident new Athens, which had already rejected other demands of the Great King. From Ephesus the Athenians, with the Ionians, had marched north and inland over one hundred miles to sack and burn the lower city of the Persian capital at Sardis. Thereafter the Ionians fared less well, but the Athenians returned from Ephesus with their story of a triumph over the barbarians. The Great King would not forget, however; daily at dinner his servant reminded him thrice, 'Master, do not forget the Athenians'. This summer his fleet and army were on the move, already in the Greek islands burning towns and temples, deporting the people. Eretria would be next, the

town in nearby Euboea which had also, though modestly, responded to the Ionians' appeal; then Athens. This the Athenians knew. The Great King was coming for revenge and they could not, after this year's festival, put away their armour and spears to return with quiet minds to their fields or workshops. The danger was imminent and could not be escaped; their mood was of exhilaration, but tinged with fear. The pall of smoke from the altar rose high over the Acropolis and the stench of the blood of sacrifice was in their nostrils.

DESTRUCTION

The debris of the small columned gateway to the Acropolis had been piled at either side of the path, to leave a clear way for the procession. It was the third Great Panathenaea since the festival twelve years ago which had so narrowly preceded the call to arms, the forced march over the Attic hills to the Plain of Marathon, and the rout of the Persian army, come to wreak on Athens the vengeance already exacted on Eretria. The Athenians had good reason to thank their goddess for their virtually single-handed success. On the field of battle they had been joined by a small contingent from the town of Plataea in neighbouring Boeotia, but the Spartan army had dithered and arrived only in time for the Athenians to display the Persian dead – 6,400 – and their own – 192. The odds had been heavily against them, but their homes and freedom were at stake. The Persians would not lightly forget the shock of a disciplined charge by Athenian hoplite

soldiers, glistening with bronze armour and ten thousand levelled spear points. The Athenian dead were cremated on the battlefield and their ashes buried there beneath a tumulus-mound where offerings were laid as to heroes, in a rite which the young men of Athens would continue to observe for generations to come. Inscribed slabs (*stelai*) recorded their heroism, and on these their names were listed by tribe, and their number could be read.

The Persians had not lightly forgotten, and less than ten years later a new Great King, Xerxes son of Darius, sent a new host into northern Greece, to drink its rivers dry, to march and sail south against the cities of central and southern Greece. Spartan heroism had delayed them at the Pass of Thermopylae but the advance was irresistible, and in the face of it the Athenians could do no better than evacuate their city and leave it to the mercies of the barbarians. The Persians sacked and burned it, overthrew its temples, and from their refuge on the island of Salamis the Athenians saw the veil of smoke rise over their homes. The decisive battle was this time to be fought at sea, and from an Attic hillside Xerxes watched his warfleet being crushed by the Greeks in the narrows of Salamis, and fled back home. At Salamis the Athenians had again distinguished themselves and in that campaigning year there had been no main trial of strength on land, but in the next year the Persians returned and it was the Spartans that led the Greeks to a resounding victory over the Persian army in the territory of Plataea, the state that had sent its troop to Marathon. The remnants fled from the Greek mainland, and were even pursued, and beaten again on

that eastern, Ionian coast which had seen the Athenian expeditionary force twenty years before. But Athens had suffered for a second time, its city evacuated, its remaining houses burnt. The citizens' return may have been triumphant, but it was to ruins.

Barely a year had passed before this renewed celebration of Athena's birthday. Upon the Acropolis the prospect was desolate. The Temple of Athena had been burnt to the ground and only the jagged profile of its lower walls marked its place. To the south, the surface had been terraced for a new temple to Athena, begun in commemoration of the success at Marathon. Blocks ready for its walls and columns still lay on the ground, but many had been bundled into a hasty refortification of the Acropolis, achieved by the Athenian leader Themistocles in the face of Spartan fears that any fortified place in central Greece might tempt and serve returning Persians. Athena had lost her old temple, and of her new one there was nothing to show but the foundations and the unfinished column-drums and blocks in the Acropolis' new walls. At least the altar still stood to receive the sacrifices; the scorched stump of Athena's sacred olive had put out a new green shoot; Athena's statue, which had been evacuated with the citizenry, survived to receive her new robe; and Athens was the richer, not with buildings but with loot from the abandoned Persian camps.

But the threat remained. Athens was to lead Greece in a continuing struggle to free all Greek lands from the Persians, and in the course of this to turn a contributory league which she led into a tribute-bearing empire which

she dominated. It was not the time to rebuild Athens' temples, and after the battle of Plataea the victorious Greek states, in a show of unwonted national unity, had agreed in the 'Oath of Plataea' to leave ruined the temples destroyed by the Persians as a memorial to the barbarity of the invaders and to the bravery of the defenders. Athens, Eretria and the islanders had suffered most, with some other areas of central and northern Greece, and the cities were for a while content to devote their energies and resources, even Persian gold, to the call of aggressive defence. In Athens civic energies were directed to purposes other than the rebuilding of temples, but military success, wealth, personal ambition and the need to create a city which could serve an empire, would inevitably persuade them that their goddess should be housed with the dignity she deserved.

CONCEPTION

The third year of the eighty-second Olympiad. Of the men who had fought at Marathon few survived, old and proud of the part they had played in the battle which had set the seal on Athens' greatness. The gods and heroes of Athens had as surely fought beside them on that day forty years ago as they had beside Achilles and Hector at Troy; in death their comrades had been touched with divinity, and their sons each year paid offerings to the tomb at Marathon, as to heroes.

The Athens that prepared for another Great Panathenaea was a different city now. Her army and fleet

had become the strongest in the Greek world. Her new leaders had been mere children when Marathon was fought, teenagers when the city was evacuated and sacked. Athens had led an alliance, fed by contributions of ships and money, which had succeeded in driving the Persians from Greek lands. The fighting continued, Cimon was sailing east again, for the last time, and soon the Persians would accept that Greece was for the Greeks, not for them. Athens' supremacy had been bought at the cost of no little ill feeling – the jealousy of Sparta, the rivalry of other Greek cities which had once been her equals or betters (Argos, Corinth), the need to keep in bounds any show of independence in the League States by action which looked far more like the repression of revolt than policing in the face of a common foe. At home political fortunes had fluctuated dramatically. The victor of Marathon, Miltiades, had died soon afterwards; Themistocles, who had helped save Athens when the Persians were at the gate and had rebuilt her walls, had fled to the Persian court after Plataea, discredited, and was recently dead. Miltiades' son Cimon had become a dominant figure through his military successes and munificence at home, but he too had been discredited, and though he had returned to fight again this was his last campaign. The new name was Pericles. His vision of Athens' role was no less ambitious than that of his predecessors and rivals, but his exercise of leadership was different. Athens' constitution became increasingly democratic, while the control of her League became more despotic. The League Treasury had already been moved

from the neutral, sacred island of Delos to Athens itself. Democracy and empire-building make notable demands on public expenditure.

The appearance of the city of Athens had changed dramatically since the devastation of thirty years ago. The fortifications of the city, her port Piraeus and the Long Walls that linked them were complete. In the city new public buildings had arisen around the market-place. Some of these were simply to serve the democracy, others were the result of private patronage. Cimon had been busy here, sponsoring new building like the Painted Stoa, with its great mural friezes executed in an imposing new style. They depicted the Athenians' heroic success at Marathon; the sack of the greatest eastern city of the heroic past – Troy; and the defence of Athens against earlier eastern invaders, the Amazons, under the leadership of Theseus and his hero companions. It was Theseus' bones that Cimon had recovered from the island of Skyros and installed in his shrine in Athens, and Theseus, who had become the archetypal hero of the Athenian democracy, had been virtually adopted by Cimon and his family. Greeks saw and explained their fortunes in terms of the heroic past which was their birthright and had been rehearsed for them by Homer and the other poets. The successes of a city's god or heroes could serve as parallels for the successes of the city itself; new adventures could even be invented the better to demonstrate the heroic or divine paradigm. In the Painted Stoa the message of the juxtaposition of Marathon, Troy and the defeat of the Amazons was not lost on any Athenian. The narratives

of Theseus' successes were a reminder of Cimon's successes in a society which did not dramatize contemporary events explicitly. This use of the stories of their past, intimately linked with the practice of their religion, had been familiar to the Athenians since the days of Homer. And in a society where the story narrated, at mother's knee or by a bard, counted for more than stories read, the familiarity was increasingly enhanced by pictorial display on buildings, walls, and objects of everyday use. Of all Greeks the Athenians especially lived in a world of icons, and the associations evoked by an image were the same as those evoked by a story, poem, or play, and far more immediate. This had been a determining factor in the decoration of public and private buildings, of works large and small, expensive or expendable, and it would be exercised subtly in the new Athens.

For it was high time that Athens' Acropolis matched its city and market-place. The time for dramatic gestures, ruined memorials, had passed. The city that led Greece desired to look the part, and the Acropolis, where her goddess lived, and which was now graced only by the many statues and votive monuments which had been erected since the Persians left, called for temple buildings to match them. The promising young Athenian sculptor Phidias had already made a colossal bronze Athena, the Promachos, which stood just inside the Acropolis entrance to greet worshippers and processions. It celebrated success at Marathon, paid for from Persian spoils. Phidias' studio had also made a bronze group of gods and heroes, including Miltiades, for dedication at Delphi to

commemorate in the eyes of all Greece both the battle and Athens' glorious stand alone against the Persians. Pericles had in mind a formal revocation by the Greek states of the Oath of Plataea, but Athens hardly needed the consent of others to her policies, and now that she had led the Greeks to what she regarded as freedom she felt entitled to use her wealth as she wished. Some complained, but the promise of the rewards of employment on the new projects, and the glory they would bring their city, determined their acceptance.

The plans were comprehensive, for Athens and for the countryside of Attica. They were costly and they would take long to realize. Pericles turned to Phidias for advice about the new temple for Athena, but there was much to decide, requiring the intervention of architects and masons and, not least, priests, since the decoration of the new buildings, drawing on stories of the divine and heroic rather than of the everyday, required their guidance too. Of necessity, plans would be altered, construction deferred, even beyond the lifetime of their creators, but the general concept and many of the details of its execution were the work of Pericles, Phidias and their advisers. Work was already beginning on a Temple of Hephaistos overlooking the north-west corner of the market-place. It was, in its way, experimental, testing new variations on the established architectural styles of Athens and mainland Greece, allowing for the eventual placing of sculptured friezes within the outer colonnades at each end – a total innovation which considerably increased the opportunities offered for iconic and narrative displays. Its exterior sculptural decoration

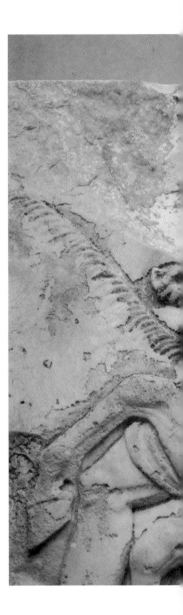

7. Horsemen (slab XXXII)
in the north frieze.

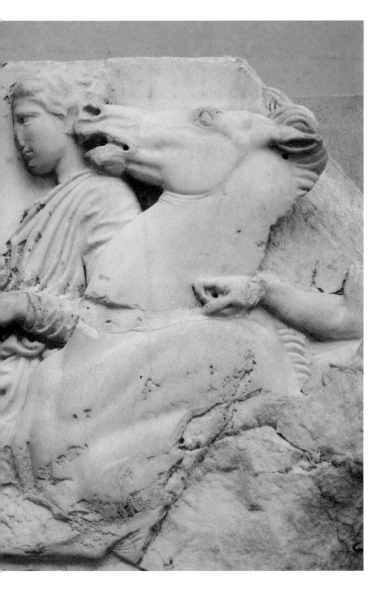

had already been agreed – old-fashioned with its scenes of the deeds of Heracles and of Theseus in the outer metope panels, subjects the Athenians had used on the Treasury they had dedicated at Delphi soon after Marathon but which they now tended to ignore, and a centaur fight. But it would be long before the whole sculptural decoration was complete, and there were other temples to replace in the city and in the countryside, at Acharnae, Sunium, Thorikos, Rhamnus.

The Acropolis itself posed special problems. The old temple had served various old and revered cults, and was not just the home of Athena's statue. For these varied roles a new building of special design would be required. The entrance to the Acropolis demanded a new monumental design, which would also have to allow for a new temple for the goddess as Victory where an older shrine had stood. But the prime consideration was the goddess herself and what she now symbolized – the pride and success of Athens as leader and liberator of Greece. This was a question of both piety and politics. The building and its sculptures had to demonstrate for all time what Athens had, through her goddess, achieved. This would be realized by size, quality of workmanship, opulence of material and decoration, and a lavish visual display of those divine and heroic stories which would remind the viewer of the building's purpose and the achievements which were celebrated. Other temples in Greece had been planned, built and decorated to commemorate success, but none with such a conscious attempt not merely to demonstrate military success and the resources lent by

the spoils of war, but to lay claim to the rewards of both unrivalled mortal heroism and divine favour.

The site for the new temple was ready – it could rise over the foundations of the temple of Athena which had been begun to commemorate the success of Marathon, but whose completion had been irrevocably abandoned with the Persian sack. It lay just to the south of the foundations of the old temple, which were still exposed to recall the Persian attack. On this northern side of the Acropolis the old cults must later be housed. But the new temple would be broader than its intended predecessor; eight columns at each end, not six, a new proportion better suiting its place on the broad Acropolis rock and better accommodating the wealth of sculptural decoration planned for it. For this there would be the two broad gables, and, unusually for such a large building, all the exterior metope panels over the columns would carry relief sculpture. Moreover, there was room at the top of the walls within the outer colonnade: metopes again at each end, as on Zeus' new temple at Olympia – or perhaps a frieze at each end, sketched in the plans for the new Temple of Hephaistos in the lower city – or, best of all, a frieze around the whole inner block within the colonnade, a revolutionary innovation for a building whose architectural idiom was traditionally opposed to such decor. The subjects would require special attention: to celebrate the goddess, but also to celebrate her city and what it had achieved. A new cult statue, too. Athena's presence could be symbolized in many different guises. The old wooden statue remained the most sacred but the maiden warrior

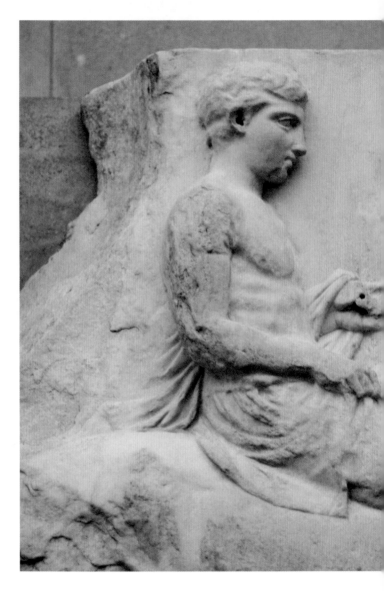

8. Horseman (slab x)
in the south frieze.

goddess deserved a more martial appearance, such as that of her bronze Promachos which stood outside. A warrior goddess then, fully armed, holding a figure of Victory in the palm of her hand: and the material, not bronze, but a monumental and extravagant display of an old technique combining ivory for flesh with gold for dress, and colossal in size. The resources were at hand, the Treasury full (this too would need accommodation in the new temple). All that was needed were the hands to execute the project, and the call went out to the sculptors and masons of the islands to hire their skills to Athens, while her own citizens acquired and practised new expertise. This might not be the last of the Great Panathenaic processions to cross an Acropolis bare of temples, but next time the promise of its eventual splendour would already begin to be apparent to citizens and visitors.

CREATION

The marble dust lay like snow on the Acropolis rock. The clamour of masons, the clatter of their mallets had been stilled for the days of the festival but the feet of the worshippers and the sacrificial animals kicked up the white dust on to hair, clothes and flesh as they shuffled past the half-finished blocks, the sheds and workshops, towards the altar and the climax of the procession.

Work had started on the Parthenon five years before. The outlines of the new temple already stood clear. The capitals were in position on the columns but the work of fluting their shafts would wait until they were unlikely to

be damaged by the building operation. The upperworks were taking shape and the sculptured metopes lay in rows ready to be raised into position. The marble walls and shafts asserted their hard, true lines through the maze of wooden scaffolding. Beyond the mason's yards and wooden shelters, on the terrace below the temple, a large, more secure structure was rising where the gold and ivory cult statue was to be made and assembled.

The creation of such a great temple, its sculptural decoration and its cult statue, had been a project more complicated than any military operation, more costly and more time-consuming. It required money, men, skills and foresight in planning, which could anticipate the effect of such a large and unusually proportioned building in its setting, and more than a touch of genius in design and execution.

The money was there, and still flowing in from subject states, which had once been partners in the league to fight Persia. The one-sixtieth part of the tribute which was set aside for Athena was accounted annually, from each contributory state, on an inscribed *stele* set up on the Acropolis. The spending of the money had to be accounted too, and another *stele* recorded in detail the expenditure on men and materials. The tight, regimented script cut in tiny letters on the smooth marble slabs was never easy reading, but the important thing was that it was there, for reference and checking, a safeguard both for those who were spending Athens' accumulated wealth, and for the many who were ready to suspect the motives and honesty of officials and their agents. Most of the men employed

were citizens of Athens, but a town of little more than one hundred thousand free citizens could not easily meet all the new demands for specialist skills, and the resident alien body – the *metoikoi* – had been noticeably swelled by an influx of craftsmen, especially from the islands, whose marble quarries had been the first to be exploited for sculpture in Greece, and where the traditions of marble cutting were still strong and well taught.

The architect Iktinos – 'the Kite': an unflattering sobriquet which reflected more on his appearance than any rapacious habits – was an islander. He was not the obvious choice for the job, but, as it turned out, a brilliant one, for architecture in Athens over the last fifty years had not offered the opportunities for a strong local school to develop. The traditional style in Athens, as in the rest of mainland Greece, was austere though subtle. The core of any temple was a single room which housed the cult statue – a physical symbol of the presence of the god. It might also serve as a store for treasure, or spoils, or as a showplace of historically significant bygones, but no acts of worship or cult took place within it other than those associated with the cult image itself. More direct communication with the gods was effected through sacrifice, and this centred on the altar, outside the temple, towards the east and the rising sun. Around the god's house, his *oikos*, ran a colonnade, the columns rising like tree trunks directly from the three steps which lifted the floor of the whole building as on a low platform. The fluting on the columns, with the sharp ridges and shallow concave grooves, abetted the illusion, but the colonnade rose with a precision

unmatched by any forest. At their tops the columns spread to low conical capitals topped by square slabs, so that the weight of the entablature and roof seemed to do no more than settle gently on the columns, lightly poised despite the obvious weight and mass of the marble. In the older temple of Athena the bulging outline of the columns had, if anything, exaggerated the sense of crushing weight, as though the building were a strongbox, welded to the rock. The new style was to be lighter even though the material was weightier – more marble, even to the roof-tiles, rather than limestone, brick and wood. The outline of the columns for the Parthenon still swelled slightly, but this in effect lightened the appearance of the building and countered the static impression given by straight lines. The stepped floor too sank very slightly to the corners, imperceptibly, yet giving an almost elastic effect to a structure which might otherwise have seemed squat and lifeless. Over the columns would run the smooth flat epistyle, then the pattern of alternating metope slabs and grooved triglyphs, petrified forms of the woodwork in older temples, in which a satisfactory compromise had been achieved between apparent structural function and sheer pattern.

To this simple formula, which had come to be called Doric, Iktinos had brought innovations inspired by his training and experience with an architectural style which expressed a more decorative idiom. The Ionians of the islands and East Greece gave their temples volute capitals and turned, fluted bases, like massive furniture, and inspired by the furniture patterns of the Near Eastern world which had played a significant role in the

development of Greek art and architecture two centuries before. There was a different flair and pattern to the decorative mouldings too, and the architectural sculpture was disposed in friezes, not crushed into metopes and gable ends. Minor elements of these styles had been long familiar in Athens, and introduced in her architecture. The outward appearance of the Parthenon would be traditional, but closer inspection would reveal the novelties – slender Ionic columns compassing the greater height of its rear room, the Treasury of the temple, a new range of mouldings, a general readiness to display ornament and sculpture (the metopes on the exterior of Zeus' temple at Olympia were all plain), even a sculptural frieze that rivalled the most ambitious of the Ionian world.

The marble quarries of Mount Pentelikon lay ten miles from Athens, clearly visible from the Acropolis and half way to Marathon. Its marble had a fine uniform grain, unlike the coarser-crystalled island marble. Cut to sharp, crisp corners and edges in architectural mouldings, or for fluted columns, even for wall blocks, it did not blur appreciation of the mason's firm hand and true eye, and it offered a clean unmottled surface for paint. The Athenians had begun to use it for sculpture a hundred years before, but this was the first Athenian temple for which only Athenian marble would be used.

The architect's specifications to the quarry master defined the overall dimensions of the finished blocks. They were cut from the marble beds by channelling around the mass desired, leaving a good margin for final trimming and to allow for minor surface damage during removal

and transport, but close enough to the ultimate form to save weight. The raw blocks, slabs and plump discs for column drums were loaded on to waggons or, for the first part of their journey from the steeper slopes, on to sleds, and in Athens they had again to be hauled up on to the Acropolis where they were trimmed to the correct size. Even then the final detail was ignored until the blocks or drums were in position – the fluting of the columns, the smoothing of surfaces and finish to vulnerable corners.

For all its novelties the layout and construction of the temple looked conventional enough. Iktinos had determined the basic proportions he would use, and expressed them in clear instructions about sizes of blocks, thickness of walls and the like, so that the master masons could assemble the building without constant recourse to him for advice or decisions except where unfamiliar details intruded. He had provided models of the mouldings and capitals for the masons to copy. He had to approve the quality of the marble provided from the quarry and he had ordered the Cretan cypress, the elm and pine to season for the temple roof, ceiling and doors. Rule of thumb and common sense, backed by intelligent anticipation of problems, had dictated the manner and pace of construction. The scaffolding had risen with the walls, to give easy access to where the blocks were swung from cranes to be levered into position on the unfinished courses. On working days a small fire, clear of the cut blocks which it might blacken, kept in readiness a pot of molten lead to pour around the iron clamps and dowels of iron or wood by which the wall-blocks and column drums

were fastened one to another. The inescapable logic of construction dictated by the traditional form of the colonnade and upperworks had meant that the main problems were logistic, not structural, by the time the blocks were ready for hoisting.

But this was a building whose sculptural decoration was to be no less ambitious than its structure. The carved metope slabs lay ready and some of the wall frieze within the colonnade, at its west end facing the Acropolis entrance, was in position. It would be some time before the roof and pediments were also in position, but the sculptors' yard would soon have to be cleared to prepare for work on the pedimental figures. In these matters architect and sculptor-designer had to work closely together. The new eight-column façades meant that there would be fourteen metope slabs at each end (two above each space between the columns) and thirty-two along each side, where there were seventeen columns. The height of the frieze within the colonnade was dictated by the proportions of the columns of the porches at each end, over which it ran, and along the flanks of the building the width of the frieze blocks was determined by the width of the wall blocks beneath them, which they matched. There had been talk of putting metopes over the porches, it seems, and some had even been carved. But Phidias had yielded to Iktinos' bold suggestion of a frieze within the colonnade, and that it should be not merely at each porch, as was intended for the Temple of Hephaistos in the city below, but around the whole central block of the building. So the metopes were abandoned and the few finished ones

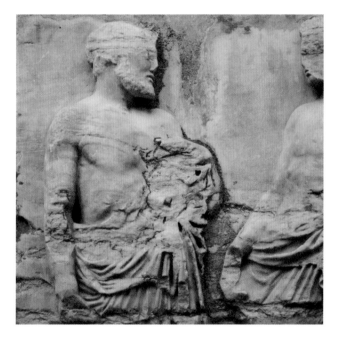

9. Athenian hero (slab IV)
in the east frieze.

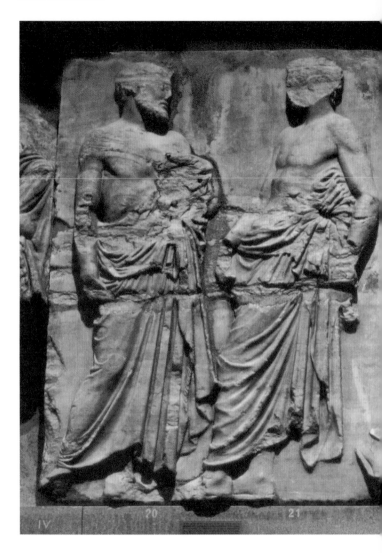

10. Athenian heroes (slab IV)
in the east frieze.

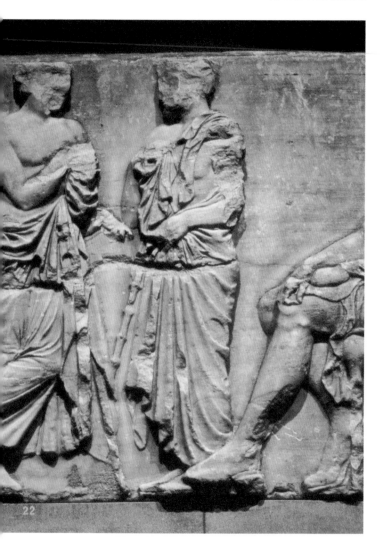

22

were to be relegated to a relatively inconspicuous position on the exterior, while there was still time to adapt the design of the rising walls to accommodate a frieze. And the subject for such a bold sculptural innovation – some five hundred feet of continuous frieze – came soon and triumphantly to mind: it would be something for Athens to relish and the rest of Greece to envy.

The carving of each metope had been assigned to an individual artist, some executing several, the less skilled few or no more than one if their competence proved inadequate. With so much to be done it took time to identify the hands which would best express the style that Phidias sought. Drawings were provided for some groups where their narrative needed to be carefully designed, sometimes in ways not wholly familiar to artists in Athens or elsewhere. There were traditional ways of showing stock subjects in Athenian art, but even these traditions diverged in different media, and in an Athens long starved of monumental expression of narrative in sculpture there was an opportunity here for the creation of new stories, suiting the special needs and functions of the Parthenon, or new ways with old stories. Through the period of Athens' dearth of monumental sculpture on architecture – the principal medium for such narrative – the minor arts like vase-painting had maintained and developed older traditions, and new ones too had been established by the muralists like Polygnotos and Mikon, in their work on Athens' new public buildings. The themes of the Parthenon's metopes called for some familiar schemes, some new. For many, contracted to

tried and expert sculptors, the specification need be no more than 'one Lapith youth fighting a centaur', yet even for this sequence of metopes, each showing just such a group on the south side of the Parthenon, Phidias had to dictate principles of design, weapons and furniture which would suit the overall narrative scheme of the series. The figures and details had to be drawn on the face of the unworked blocks provided, be approved, and then the sculptors could set to work, letting the apprentices cut to the depth of the eventual background where there was no figure, working quite swiftly with the sharp iron point that brought off large marble flakes. Then the master took over, refining his sketch, working slowly towards the surface he sought with the claw chisel, which safely gouged broad swathes on the stone, then the flat chisel, and rasps and rubbers to smooth away the tool marks. Where dress fell in deep, shadow-catching folds, or there was deep cutting to be attempted between the legs of horses, or even undercutting, since some of the metope figures seemed to spring clear of their background, then the bow drill was brought out. An assistant spun the shaft, and rows of close-set holes were drilled straight into the surface to define masses which could be safely broken away, leaving the chisel to finish the folds in drapery, or intricacies of anatomy.

The metopes were ready. The frieze had its own problems. The relief was shallower, the figures shorter, but the execution was the same. The great unified theme needed careful planning in the placing of figures and their numbers. For the west end the artists had been able to enjoy

some freedom in the planning and execution of figures on each slab – 'two horsemen and a youth', 'a horseman, a youth and a marshal', 'a bearded horseman' – though specifications of dress were still important. It was going to be more difficult on the rest of the frieze which was more crowded, and it looked as though much of it might have to be carved on the slabs after they had been set on the building itself, high on the scaffolding forty feet above the marble pavement.

For the pedimental figures planning had barely begun and the procedures of design and execution would be far different from those for the reliefs. They too would be carved here, on the Acropolis: it would be too difficult and dangerous to move the finished marble figures, over life-size, any great distance from workshops to their final resting place. And this would mean that once they were finished they would be appraised and enjoyed at close quarters, before they were set high on the building. Iktinos had predicted well enough the exact dimensions of the gable opening in which they would fit. The subjects were agreed, but there was some room for discussion about the number and identity of the figures to be carved. Here special considerations of cult and history had intervened which meant that these would be crowded compositions, more crowded than any yet seen on a Greek temple. They would be carved wholly in the round, to stand on the three-foot-deep pediment floor. Iktinos was anticipating the problems posed by the extra weight of the central figures by planning for iron bars to be set in the floor, to carry some of the load back on to the rear wall of the

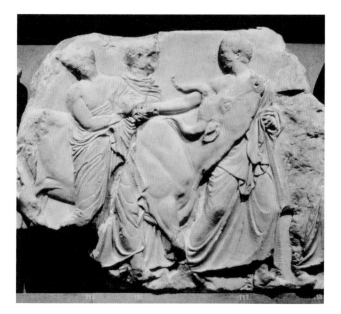

11. Attendants with cows for sacrifice
(slab XL) in the south frieze.

pediment and not leave it to be supported wholly by the projecting floor. Small clay models had been prepared to test how many figures, in what poses, might be set in the awkward, low triangular field. Once these were agreed the overall dimensions for each figure could be determined, the marble blocks for them chosen and inspected. But it would be long before point or chisel would be set to them and their delivery could be long deferred. For each figure a full-size clay model had to be created, worked on a wooden and metal frame to ensure its survival through the months that might pass before it could be dismantled. Some of the broader modelling would be left to apprentices, but the master intervened at every stage to check pose and proportions and eventually to check and execute detail. The process was familiar enough despite the relative lack of experience in Athens in the production of major sculpture in marble, because it was exactly that required for the creation of bronze statues, and for Phidias' team the Marathon group at Delphi and the colossal Athena Promachos on the Acropolis had required just such models, from which the bronzes were cast, albeit piecemeal. The translation to bronze was direct. The translation to marble, an inferior material in the sculptor's eyes, but necessary for this setting, was no less demanding technically and far more laborious. An array of plumb lines, setsquares and drills, frames and tripods, were required to enable the masons accurately to predict, and sometimes to mark by drilling, significant points in the marble block to which they could safely work before the desired, ultimate surface of the figures was approached. By then there

was need for yet more precise measurement to determine the set and placing of features, or locks, or dress, or limbs. In the final stages the masters would take over and, however painstakingly completed had been the stages executed by other hands, it was theirs that revealed the finished surface, and added the ultimate detail to what in outline had also been the master's design.

It would be years before the gable figures were ready. When they were, the minor errors of measurement or pose would be revealed, and slices discreetly cut from bases or backs so that they could fit each other in their appointed places under the sloping pediment roof.

The final preparation of the sculptures before installation was not simply a matter of carving or adjustment of size. There were accoutrements to add in metal – a horse's harness, a spear – for which drill holes had been left in the stone. These had to be cast or hammered and affixed. And then came the paint. The surfaces had all been smoothed, the flesh parts received a slightly higher polish and would be left in the plain white marble, but dress, weapons and backgrounds had to be painted, and the waiting metopes had already received their colours. A dark red background helped to lift figures even more realistically off the stone. Reds, blues and yellows picked out the dress and trappings, and the hair, eyes, brows and lips of the figures were painted so that their features stood out boldly even at the great distance from which they would ultimately be viewed. And on the dress intricate patterns were depicted, borders and figures. Little matter that they would no longer be seen when on the building.

For the perfect building the execution and finish claimed perfection too. What the human eye might miss, the divine might criticize. The backs of the pedimental figures would be carved and finished with no less skill than their fronts, but would be admired by mortals only for as long as they were visible in the sculptors' yards, or until time or impiety brought them down again, off the building, to instruct and delight even barbarian successors to the tradition that had formed them.

The already finished sculpture displayed to Athenian eyes a style and presentation not altogether familiar. Bronze statues from the same studios expressed somehow a different fire and presence, and those who had visited the Temple of Zeus at Olympia might have looked for greater nuances of emotion. But the pervasive effect was of calm control, even in violent situations such as those which were the dominant themes on the metopes. Here human and animal bodies expressed brilliantly motion or energy, or peace and repose, almost introspectively. The mortal figures behaved with the calm assurance of gods, and the gods fought or observed with an almost human indifference to their supernatural powers or immortality. Never before had the divine and human been so closely assimilated, even confronted, and the heroic figures, of which there were many on the metopes, and whose status lay between gods and men, seemed to demonstrate that spiritually as well as physically there was more in common between them than divisive.

The persistent theme was the naked male body – nothing surprising in that to the Athenians. Indeed,

familiarity with nakedness was one thing which marked Greeks off from the barbarians. Not only did their athletes compete and exercise naked in public view, but the common dress for young men, a short cloak fastened at the neck, was totally revealing and there were no trousers, such as Persians wore. Even in battle only defensive armour, if it could be afforded, concealed bodies which moved the more effectively untrammelled. The male body (not the female), completely bared, was admirable and admired. Lean muscled bodies had teased sculptors with their patterns of anatomy long before that anatomy was at all well understood. Before Marathon sculptors had been trained in a tradition which at first demanded the presentation of the body as a series of patterns, assembled in a manner which made it possible for a four-square, symmetrical figure to be carved with no more guidance than sketches on a grid drawn on the block sides, to determine the basic relative proportions. This the sculptors had learned from Egypt, together with the notion of making colossal figures of hard stone. Gradually, however, the patterns and masses of the body came to resemble life more and more – usually in unrelated details and still with a strict symmetry except for the few active figures, generally carved for buildings, which were little more than enlarged reliefs. The figures had symbolized live bodies without being lifelike, but from about the time of Marathon the function of the muscles and bones that created the admired surface patterns was appreciated, and by successfully denoting a shift of weight or balance in the standing figures the sculptors showed that at last (and in a way never seized by barbarian peoples

whose monumental sculpture was so much older than the Greeks') their figures could express the structure, the inner life of the body, and not just its exterior patterns. For all this, of course, the naked male provided the ideal model, and the ideal male nude had become the archetypal image for god or man. The Parthenon sculptors carved as they had been taught. Phidias, by example or instruction, guided them to a common style, without eliminating individuality of execution. But life was studied now, not patterns learnt by rote. Yet it was not slavishly copied, and preoccupations of pattern and proportion were as vital to the sculptor as to the architect. Neither sculptor nor viewer considered what later generations might contribute to this craft, since for the period and purpose for which the sculptors had worked they expressed perfection, as they saw it and as they had learnt to create it.

The gaunt unfinished building was being assembled as a showpiece of architectural elaboration and of evocative narrative sculpture, expressing the power of the divinity honoured. But it was also a house, and the only inescapable reason for a temple was the cult image of its god which it would protect. For the Parthenon an image was planned such as Greece had never seen before. The warrior goddess would stand nearly forty foot tall in her temple, her flesh ivory, her dress gold, her base, dress and armour decorated with yet more figures. The technique was an old one, and wooden, sometimes gilt figures could be given marble faces. But the scale combined with the materials was new. The old, quaint wooden statue had acquired its sanctity from its sheer age and

appearance. The new one would demand, even impose, respect for its size and opulence, as well as the quality of its workmanship.

The building being prepared for its construction had to be secure. A fortune in ivory and gold would be handled and had to be accounted for. They said that Phidias, anticipating trouble, was going to make the gold removable so that its weight could be checked. Accountability was of more moment to many Athenians than artistry.

For the figure of Athena Parthenos, the maiden, a full-size model was also required. The flesh parts would be carved separately in ivory strips to be dowelled and glued together. From the dress, moulds would be taken so that the gold could be pressed and beaten upon them and then reassembled piece by piece; not on the model, which could not serve as mount since its material was insecure and impermanent, but on a wooden frame which copied it in all but detail of surface. There would be metal too, to cast and hammer, not least the gilt relief figures which would be applied to the goddess's shield (Phidias had in mind to have the shield of his bronze Promachos decorated in the same way); and inlays of coloured glass to be cast, of stone and wood to be carved.

In four years' time the cult statue should be ready and the temple ready to receive it. With so much of the building already standing, so much of its decoration already carved, there was a sense of euphoric anticipation in the procession this year. Many Athenians were proud and happy enough to share their city's wealth by being paid to work on the new temple. Already there was much to show

for their labours and from the lower city it became possible to imagine how their Acropolis might again look, crowned by a temple which would be the envy of all Greeks. The city had had its problems, even defeats; its politicians could be devious; its empire was restive, but under control; last year they had promoted a joint Greek resettlement of Sybaris in Italy, a city whose name had become a legend for luxury and prosperity before the disaster which many interpreted as the just deserts for its pride. The mood in Athens was constructive, optimistic, but wary.

COMPLETION

'Really, Pamphilos, I have never seen a city so gorged with icons as your Athens. Everywhere I look, in your home, in the streets, in the fine buildings of your market-place, I see the stories of our gods and heroes, and your new great temple seems alive with them. I have never seen anything like it. We live well of course, if modestly, in Plataea; we admire good things and fine craftsmanship. The honours and wealth heaped on us by the Greeks in days when the Persian army was defeated on our land and my father was young have brought us a fine new temple of Athena too: but nothing like this. I know the stories, of course; I learnt them at home, at school, and I read the poets and listen to the rhapsodes at the festivals when they recite the epic poems about our past, but there is a lot here in Athens that I do not recognize or understand, and in the excitement of the great procession and sacrifice yesterday, I really couldn't take it all in.'

Pamphilos' guest was impressed, and puzzled. He had been invited to attend the Great Panathenaea in which the new temple to Athena was to be dedicated. Any Plataean evoked a natural sympathy in Athens, not least on an occasion such as this. Of all the Greeks the Plataeans alone sent men to fight beside the Athenians at Marathon – a small contingent, but highly valued and never forgotten. Of all the Greeks the Plataeans were remembered in the prayers for the good fortune of Athens at the start of each celebration of the Great Panathenaea. That festival had been celebrated thirteen times now since Marathon.

When the Persians had come again to Greece, and sacked and burned Athens, they had burnt Plataea too before they were defeated on Plataean fields. The Greeks had honoured the Plataeans for this, and gave them money from the Persian spoils to rebuild their city. Every year the Plataeans paid honours to the tombs of the Greeks who had fallen there, as to heroes, and every four years commemorated Greek deliverance from Persia with a festival, the Eleutheria. But in Athenian hearts they held a special place for standing at their side at Marathon. They too had built a new temple for Athena – the warlike, Areia – and for their temple Phidias himself had created a cult image: not as lavish as the Parthenos, but with gilt wood for her dress, and Athenian marble for her features, hands and feet, where the goddess in Athens had sheet gold and ivory.

Pamphilos and his friend returned to the Acropolis on the day after the sacrifice and processions. The rock

still lacked any major entrance-way or other substantial buildings apart from the Parthenon, and closer inspection revealed that the Parthenon itself was not quite complete. Most of the work was still to be done on the pedimental figures, only one or two of which were in place, and the workshops would in a few days be busy again. The carving of the colossal figures was the most time-consuming of all the sculpture and required more regular attention from the master sculptors. The slackened tempo would mean a long wait before the last figures were raised and the accounts closed. But the giant workshop in which the gold and ivory cult image had been constructed, before being dismembered and reassembled in the temple itself, had already disappeared. In all other important respects the temple was complete and, the vital factor, the image of its goddess had been installed and consecrated.

Athens' priests, poets and artists had always taken an original view about the stories of their past, of the age when heroes and even gods might walk with mortals. The stories were part of their history and some Athenians could trace their families back to divine or near-divine ancestors. But it was a history which was not so much known or even recorded as revealed. It provided them with a constant example and parallel to contemporary events and problems, and it was natural to view the present in terms of the past, which could serve as a guide or warning, even a promise for the future. The stories were passed by word of mouth, learnt as one learns the techniques of living, but an oral tradition is an evershifting one, prey to variations through inventiveness, to a desire to introduce

a topical new element, to inaccurate or muddled memories. The stories were more formally expressed in poems, hymns and plays, but performances were few and far between, and reading was boring and difficult. There was no absolute version of any story and part of the joy of hearing them, at home or at a public festival, was the excitement of discovering novelties which might shock the conservative, or seem suddenly right because relevant. The creation of such novelty was not a question of tampering with truth, but of helping to create a past which had meaning to the present. Poets could be liars, but their inspiration came from the gods. Moreover, familiarity with the stories was daily strengthened by familiarity with images – well-known ones like the hero wrestling with a lion which provoked the instinctive response 'Heracles', but also more obscure ones where visual signals of dress or behaviour, sometimes helped by inscriptions, gave the clues. These were not puzzle pictures since they appeared in and for the society for which they were created, whether they were painted on a water jar or carved on a temple. The level of understanding differed, of course, from child to labourer to bookish adult, but the general message was clear – here are the gods and heroes of our past performing to please and instruct us, to warn us or protect us. The fact that the message was different at different times to different people did not mean that it was misunderstood, and the fact that one image could carry many messages enhanced its value rather than turned it into an intellectual game. But Athens was supremely rich in these images. At this time no other Greek city had painted

scenes of gods and heroes, as well as scenes of daily life, on mere clay jars, let alone on the wooden plaques and panels that hung on walls or the many more expensively decorated objects of gold, silver, or bronze. The images that an Athenian accepted and understood could not all of them communicate as readily to a Greek from another city, except of course for those images which employed the conventions of pictorial narrative common to all and in the service of the best-known stories. There were figures and stories and allusions that belonged to this time and city only, and even a Heracles could seem a very different hero in his Boeotian home, while the Theseus that the Plataean had seen on the walls of buildings in Athens' market-place was by no means the hero he knew from stories and pictures. No wonder he was puzzled.

As the two friends approached the Parthenon and looked up to its western gable they saw only two figures in place, at the centre. 'Yes, Pamphilos, I see your Athena, and there is Poseidon with his trident, but they are quarrelling and I don't know any such story. Poseidon was for the Trojans, of course, and Athena for the Greeks, but surely they never fought at Troy. And Poseidon is the father of your Theseus and has been worshipped on your Acropolis, though I know he is not held in as much honour in Athens as he is in some other Greek cities. Forgive me for pestering you with questions but please tell me why? – when?'

'I see your problem; it would have seemed odd to us some years ago, but our priests find that Poseidon once claimed our land of Attica, and even threatened to

flood it if he did not have his way. But Athena fought him and promised us the olive – you can see it up there too, and her tree there to our left: that proves the story. Zeus parted them and awarded her the prize but left Poseidon his due share of worship here as well. High between them Phidias intends to put a golden thunderbolt to show Zeus' judgment. It will make a fine showing in the rays of the evening sun. As for Theseus, somehow our songs and hymns tell less of him now than they did when I was a child and when those paintings that you saw were first displayed. We think as much of others now – you heard them honoured in the hymns yesterday – our old kings and heroes of Athens and the Attic land. It is their figures that will fill the rest of the gable, but now you can see only the models for most of them and certainly would not be able to identify them without my help. They have not yet even chosen the blocks for most of them on Pentelikon.'

The subject in the gable at the front, eastern end of the temple, presented no problems. It was, as the Plataean recognized, another statement of Athens' origins, this time the birth of her patron goddess, possessor of temple and city. She stood fully grown and fully armed before Zeus, having sprung thus from his head in the miraculous birth, helped by the axe of the god Hephaistos, who appeared also, starting back. This was a well-known theme throughout Greece, and, as expected, the divine birth was attended by other gods and goddesses on Olympus. For these figures Pamphilos had to turn to the workshops where the guest marvelled most at the almost languid sensuality of the goddesses, a mood he had never

encountered before in images of the divine. Pamphilos named figures readily but they lingered over one whom the Athenian named as Dionysos – 'Look, he is seated on his panther skin.' 'We know Dionysos well enough,' his guest replied, 'indeed it was from us that you learnt of the god. But here he sits apart, looking away from the birth, and he seems so youthful, not at all like the master of the vintage and ecstatic revels that we know.' 'You are right,' said Pamphilos, 'but remember that Dionysos was a newcomer to Olympus, and on the temple he will be looking out over the edge of the Acropolis towards where his temple lies on the lower slopes. We know of those wilder aspects of his worship as well as you, but it is for him that our poets offer their plays each year, and in his honour they stage their stories of gods and heroes. You should have seen Sophocles' play about Theban Antigone two years ago. It troubled the heart and conscience of us all. The festival is in the spring and we have a procession then, more exciting than yesterday's, passing through the market-place to Dionysos' temple and the theatre above it, paying respects to the shrines and altars along the way, as we did.' 'I can see, Pamphilos, that Dionysos too has many different faces for us Greeks.'

They turned back to the temple to walk around the outside, viewing the sculptured metopes, and the Plataean marvelled again at the pictorial wealth of the building. 'We can leave the south side,' said Pamphilos, 'you can see it later. It is the old story of the Lapiths fighting the centaurs at the wedding feast of Peirithoos, which they had disturbed by their drunkenness, and at the centre is

a clutch of slabs from an earlier scheme for decorating the temple, that do not make much sense because the series is incomplete. There is a grand centaur fight on Zeus' Temple at Olympia, you know: ours is fine enough but is just a series of duels. It shows us all how civilized Greeks can triumph over the wild and uncivilized – a simple message we all understand. But come along to the temple front again and look above the columns, at the metopes. The battle of gods and giants is an old and loved story – you saw it woven on the robe we gave the goddess. The Olympians defeated the powers of darkness as triumphantly as the hero Lapiths did the monstrous centaurs, and as triumphantly as our grandfathers, Athenians and Plataeans, drove off the Persians from Marathon years ago. Pericles, the priests and Phidias chose this pattern of stories to remind us how mortals can sometimes rival even divinity when their struggle is just, as ours was, and I know that any Plataean like you will share with us a pride in Marathon greater even than in that other battle, the last in Greece against the Persians, fought near your home.'

'Yes, Pamphilos, we remember, and the way your festival and temple call back those heroic days is inspiring. They say that gods and heroes long dead joined in the fight for Greece that day.' 'I know,' said Pamphilos, 'but there is yet more here to answer pride in our city and what its fighters won, as you will see. Look now along the north side.' 'Troy sacked,' said his guest, 'of course I know the story well and recognize the icons – the Greek ship, Menelaos threatening Helen but Aphrodite saving her, Aeneas escaping with his father and son.

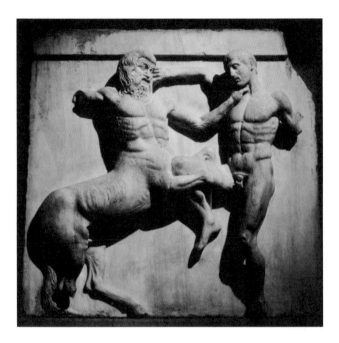

12. Centaur and youth on south metope 31.

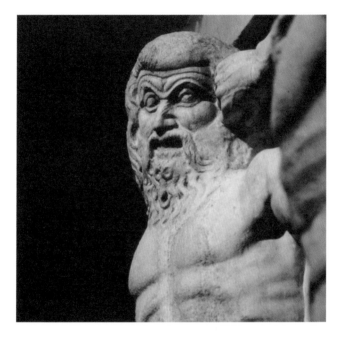

13. Detail of centaur on south metope 31.

The songs of Homer and the other poets tell a sorry tale for Greeks which I never tire of hearing and seeing.' 'Yes,' said Pamphilos, 'in this we Athenians see the sack of a mighty city, as ours was sacked, and we see cruelty and hope, and we see how those who conquer through right can wreak vengeance wrongfully, how those who deserve defeat can still behave with honour and win respect. Our playwrights could not create a more troubling story, and they turn often to its themes. It was all the gods' will, of course, and gods fought beside both the Greeks and the easterners on the Trojan Plain. At the right there you see the gods who supported the Greeks, and on the final slab our Athena standing before the mother of the gods, Hera.'

They passed round to the west end, beneath the gable where Athena and Poseidon waged their timeless battle for Athens. 'The fight with Amazons,' cried the Plataean, 'but where is Heracles? And I see you dress your Amazons like Persians; I know the costume from pictures and the rich garments displayed with the Persian spoils in our temples at home. This is all new to me.'

'It is a complicated and fascinating story,' said Pamphilos. 'After we sailed with the Eretrians to help our Ionian kin, and marched on the Persians to burn their city at Sardis, the start of all our troubles with Persians, ours and yours and all Greece's – our priests found that Athenian Theseus himself had joined Heracles' famous expedition to the east against the Amazons long ago; and then that the Amazons had invaded Attica in revenge, just as the Persians did when our grandfathers fought them.

But the Amazons reached Athens and had to be driven back from the Acropolis by Theseus and his hero companions. This is the battle we celebrate here.' 'But where is Theseus,' asked the guest, 'and will I see him also in the centaur fights around the corner?' Pamphilos, for once, had no answer ready. 'Somehow', he said, 'we have come to think less of Theseus, just as Heracles too figures less on our icons now than he did in our fathers' and grandfathers' day. Perhaps we had too much of him – some have even doubted his Athenian blood, you know.' He paused. 'But here we can start looking at the great frieze. If you look up between the columns ...' 'I know,' said his guest, 'I saw yesterday how your sculptors had decorated the top of the wall behind the columns, and I was amazed, for I had never seen a building with such a frieze. I looked for a battle or encounter of gods and heroes, and instead I seemed to recognize Athenians in a procession to their goddess. I must confess I was a bit afraid you might pay the price of arrogance, but at this end of the building all I see is a grand cavalcade of heroes, not warriors, it seems. And it runs on along the sides, and there in front – I understand now – the chariots with men leaping from them. These are the holy exercises we saw in the procession where it crossed your market-place, where we paid respect to the graves of the long dead. In front come the officials of the procession. I see your elders, musicians, the animals of sacrifice, water-carriers. I recognize all this, but where are the citizens, the soldiers?'

'Think,' said Pamphilos, 'of what we have seen already on our temple. Think of why you are here, a Plataean.

Have we not many times already mentioned Marathon and recalled our stand against the Persians. The first temple that we started to build here was for Marathon, but the Persians destroyed it, and over there stands the great bronze Athena Promachos built from the spoils of the battle. Our common stand at Marathon inspired Greece and surely determined that we were fated to lead Greece to final victory.'

The Plataean was slightly disturbed by the vehemence of the young man's pride, but was too polite to allude again to Athenian arrogance. 'Our goddess, through us and our heroic dead, saved Greece,' Pamphilos continued, 'and each year we go to Marathon to give thanks and worship at the tomb of our dead, just as you do at the tomb of the Greeks who fell at the last great battle at Plataea. It was their sacrifice that led eventually to this' – he gestured at the whole great building, gleaming in the morning sun with a brilliant reflection of fresh-cut marble, garlanded with its coloured sculptures. 'We fought at Marathon ...': even those who were not born then seem to claim the glory still, thought his guest. 'We fought at Marathon, and won; we led Greece to final victory, and we reward ourselves and our goddess with this temple.'

'Our Marathon-fighters had celebrated the Great Panathenaea hardly more than a month before the battle: did you know that? The goddess' blessing was still fresh on them. And so we celebrate the dead both at their graves and in this memorial to that holy day. We come close to the heroes of our past on these occasions. Those men and boys certainly did when they went from worship to

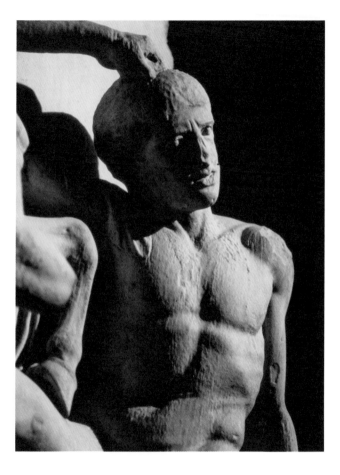

14. Detail of youth on south metope 30.

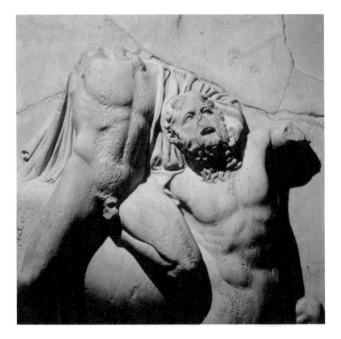

15. Centaur and youth on south metope 2.

battle, and showing them in the hero races and chariots makes it clear enough that this marble procession is of no ordinary Athenians. They say that if you count them – but my neck aches staring up at them too long and we can trust Phidias to have seen that things are as they should be. But have you seen where the cavalcade is being led?'

They moved to the front of the temple again, and spent a while moving across the façade, peering up between the columns. 'Now I understand,' said the Plataean, 'we are in the market-place and there in the centre the sacred robe is handed to the magistrate, with the priestess and attendants with their stools. But the procession is greeted by the gods, just as we visited their altar in the market-place – another novelty for me, Pamphilos, an altar for the twelve Olympian gods. Our poets tell us they are a family, but we have never worshipped them other than as individuals, for their special gifts or as guardians of our cities. I recognize them all, I think. They look wonderfully alive, yet more than mortal. There is Hermes, his travelling hat on his lap, nearest the mortals as usual, and I suppose it is your youthful Dionysos that leans in that familiar way on his shoulder. Demeter, the goddess with the torch; Ares with his spear; Hera and Zeus – they are easy, and the winged goddess beside them, Iris, or perhaps Victory in these circumstances. Then on the other side Athena – is that her aegis on her lap, snake-edged – I can barely see? Hephaistos has his crutch, then, I suppose, Poseidon. Apollo and Artemis, obviously, then Aphrodite and, how charming, Eros with her parasol. You do bring your gods down to earth, Pamphilos; don't

you sometimes think you are too familiar? In front of the gods the groups of young and old men are, I suppose, heroes.' 'Yes, the ten who led our tribes.' 'And the women at the head of the procession are those I saw who attended the ceremony of the robe, and they seem to carry symbols of their work – those must be the legs of the sacred loom that we saw displayed. And along the south side, I see, the rest of the procession, rather as on the north. It all makes sense, Pamphilos, you are right. A brilliant way to celebrate the gods, your goddess, your heroes, your city. You must be very proud.'

It would take many more visits before the friends had exhausted the detail of the sculptures on the new temple, and for a while they stood before it, contemplating the Olympian messages of its façade. But there was more to see – the cult image of Athena Parthenos, the glory of the temple, the scandal, some said, of the whole project for its opulence. They approached the porch, already festooned with a selection of Persian spoils dedicated to the goddess, and stood before the open doors. The interior was lined with a double tier of columns and, at the back, the goddess seemed to dwarf even the massive architecture of her house. Light from the windows at either side of the door filtered through the colonnades within, and light from the door played on her, some reflected up on to her dress and features from the shallow film of water on the floor before her. Pamphilos explained that this would keep the ivory from cracking, but it also reflected an unearthly, pallid light on the image itself. The first impression was of size, then of gold, gleaming from her

armour and dress, then, as their eyes grew accustomed to the shady room after the sun outside, the warm flesh tones of the ivory, the colours of wood, glass and stone on the dress, armour and base. Victory had alighted on the palm of her outstretched right hand. Her shield stood at her side, its rim held steady by her left hand, and within was coiled the great serpent. 'They say our earliest kings were snakes,' explained Pamphilos, 'and some show them with snake legs even now. King Erechtheus was a serpent. He had been protected by Athena, and he introduced her worship to the city, built her oldest temple, first harnessed four horses to a chariot. I told you how much we now hold in honour our earliest kings and their hero sons. They too were close to our goddess; they taught us about her power and showed us how to win her favour.'

They moved into the side colonnades for a closer view of the image. It seemed alive with figures. The helmet had three crests, raised on the figures of recumbent sphinxes, its cheekpieces bore griffins, its peak the foreparts of winged horses, silvered, gilt. The thick soles of the goddess' sandals carried a fight with centaurs, and there were other echoes of themes the friends had admired on the temple exterior. Within the hollow of the great shield, as in the vault of heaven, was painted yet another battle of gods and giants, and on its exterior gilt bronze figures were attached to narrate another fight with Amazons. The warrior women were not on horseback here, as they had been on some of the metopes, but seemed to battle their way on foot up the shield, as to the Acropolis, and were hurled back by the Athenians. The guest forebore to ask

where Theseus was this time, but could not resist some speculation about the names of the heroes.

Before they left the building they turned again to the image and Pamphilos drew his guest's attention to the statue base and the figures on it. 'Now this is something I can understand,' was the response, 'for our poet Hesiod sang of Pandora – I had to learn the poem – the woman created by the gods and endowed by them with all qualities and gifts to offer man. But, Pamphilos, she was the deceiver of mortals, of Epimetheus, just as his brother Prometheus had been deceiver of the gods, persuading them to take from the sacrifices of animals only the inedible bones and fat, and so she withheld Hope from mankind. I cannot understand why you have her story on the base of your goddess, and it seems I must end our visit to your temple with questions, as I began it.'

'I know the tale,' said Pamphilos, 'but we have a different one and we view Pandora – sometimes we call her Anesidora – in a different light. She was fashioned by Hephaistos from clay, dressed by Athena herself, who gave her the skills of weaving. Then the other gods blessed her with all the gifts that mankind requires for a life of god-fearing peace. These were also their gifts to us Greeks, just as Demeter taught us how to grow crops, Hephaistos how to forge weapons, and our heroes how to use them. She symbolizes for us those gifts of peace, for which we bless our goddess, as much as for those more warlike ones which have proved Greece's salvation, and which we celebrate elsewhere, in other ways. Athena is a warrior, but she is also a woman. She strengthens our citizens'

right arms in the fighting line, she counsels their wives at the loom and in their homes. She is served by women, as you have seen in life and in marble – the priestess, the girl delivering the robe, the weavers of the robe, our sisters and daughters who stand with jug and bowl for the libation of sacrifice, greeting and victory. You have seen the gods, in the gable above us, attending the newborn goddess; in the metopes there, defeating the giants; in the frieze over the porch, greeting our heroic forefathers; and now here, on the goddess' base, bestowing the gifts of peace. Athena is everywhere with them, and yet above them since this is her house. Your Hesiod took a hard view of man's lot and his relations with the gods. I think we Athenians have come to feel more immediately the warmth of their favour and blessings. This is why we have survived, why we think of ourselves as natural leaders of those who share with us the Greek tongue, why we above all Greeks dare claim their patronage.'

The Plataean said nothing, and as they retraced their steps to the city below his wonder at what Athens had achieved in honour of their goddess was tinged a little with apprehension at what they might be courting from jealous gods or jealous mortals, and he thought of the wealth contributed by Greek cities that lay in the treasury behind the goddess. He knew the Athenian poet better than Pamphilos had guessed. *Wisdom is by far the better part of happiness and there must be no irreverence towards the gods. High-sounding words of proud men are punished by great misfortunes and, in old age, teach them to be wise.*

THE PARTHENON'S ROLE AND SIGNIFICANCE, THEN AND SINCE

THE MESSAGE OF THE PARTHENON was an immediate one for the fifth-century Athenian. Apart from its glorious cult statue and the effect of its sheer presence, its message remained significant for as long as the events it celebrated remained significant. So long as Persia remained a power in Greek politics and life the message remained clear. Alexander and his successors could recall it in their dedications for later victories over easterners, but once Greece became a Roman province Athens was regarded as the still honourable seat of an old and respected culture rather than the champion of Greece against the barbarian, and by Pausanias' day (the second century AD), the Parthenon's sculptures were simply illustrations of myth and the frieze was unremarkable, its significance forgotten, and therefore ignored.

We cannot easily chart this decline. Within a century of the completion of the Parthenon the philosopher Plato, who was critical of the deceptive realism of the art it displays so well, could use images derived from its decoration to illustrate points in his arguments –

the most sophisticated of ancient applications of myth and art.

Nonetheless, the effect of the Parthenon sculpture on contemporary and later arts is easy to misjudge. What has survived must represent a minor part of even the marble architectural sculpture of the Classical period. We lack most of that from other Classical temples in Athens and Attica, except from the Temple of Hephaistos, and we have lost virtually all the bronzes and a very high proportion of the major products in other media, including all wall and panel paintings. We probably have barely one per cent even of that humble but informative craft, vase-painting, and this we owe in large measure to the happy coincidence of the Greek export trade to Italy and the conditions of burial in Etruscan tombs which preserve the vases so well. It is easy to overestimate the Parthenon's importance in this respect, even to declare that individual figures on its nearly invisible frieze were responsible, in detail, for the appearance of comparable figures in contemporary and later arts. This is surely absurd, and we have no reason to believe in the circulation of models or pattern books of motifs for the instruction of artisans. Classical art exhibits none of the mechanical repetition that such behaviour encourages. The echoes of motifs or figures that we see in the marbles reflect a common stock rather than necessarily the marbles themselves. Our inability to recover from other arts the appearance of major groups, like the centre of the east pediment, is a measure of how uninfluential they were. And the absence of any images which clearly derive from the composition on

the Parthenos shield should warn us against using, for instance, vase-painting to reconstruct lost works. The Athenas and Victories made in following generations owed much, no doubt, to the Promachos and Parthenos, but did not copy them. Copying begins with the Hellenistic period, in a generalized way for the Greek courts, in a mechanical way for Roman patrons. That the Parthenon frieze in some way inspired the composition on the Augustan Altar of Peace in Rome is as unlikely as that it had itself been influenced by the friezes of tribute-bearers on the buildings in the Persian capital at Persepolis. The 'influence' and 'quotation' of works of art in antiquity are phenomena that need cautious investigation and are not elucidated by comparisons between images that may own common sources but not themselves be related.

The Christians' attitude to the marbles, especially the metopes, we can judge readily from their harsh treatment of these pagan figures, which were severely battered by early Christian hands in the centuries prior to the Ottoman takeover of Athens in 1456. Only in the nineteenth century, by which time western culture had for centuries cherished both the literary genius of Greece and the veiled view of her art offered by Roman monuments, did they begin again to bear an influential message. It was a message less well read by scholars, whose view of ancient Greece tended still to be starry-eyed, than by artists. Their knowledge and understanding of Greek art had been formed by almost anything other than original works. The Neoclassical movement of the eighteenth and early nineteenth centuries was nourished by Greek literature and Roman

art, reinterpreted by the Renaissance. The arrival of the marbles in London, via an undertaking whose legality and propriety has aroused heated controversy from that day to this, came as a timely shock to Neoclassical artists like John Flaxman and Antonio Canova, who acknowledged the force of the revelation. The words of a minor artist, the historical painter Benjamin Haydon, vividly describe the novelty which, in our fuller familiarity with original Greek art, we may inadequately prize.

> To Park Lane then we went, and after passing through the hall and thence into an open yard, entered a damp, dirty pent-house where lay the marbles ranged within sight and reach. The first thing I fixed my eyes on was the wrist of a figure in one of the female groups, in which were visible, though in a feminine form, the radius and the ulna. I was astonished, for I had never seen them hinted at in any female wrist in the antique. I darted my eye to the elbow, and saw the outer condyle visibly affecting the shape as in nature. I saw that the arm was in repose and the soft parts in relaxation. That combination of nature and idea, which I had felt was so much wanting for high art, was here displayed to midday conviction. My heart beat! If I had seen nothing else I had beheld sufficient to keep me to nature for the rest of my life. But when I turned to the Theseus and saw that every form was altered by action or repose – when I saw that the two sides of his back varied, one side stretched from the shoulder blade being pulled forward and the

other side compressed from the shoulder blade being pushed close to the spine as he rested on his elbow with the belly flat because the bowels fell into the pelvis as he sat – and when turning to the Ilissus, I saw the belly protruded, from the figure lying on its side – and again, when in the figure of the fighting metope I saw the muscle shown under the one arm-pit in that instantaneous action of darting out, and left out in the other arm-pits because not wanted – when I saw, in fact, the most heroic style of art combined with all the essential detail of actual life, the thing was done at once and for ever. Here were principles which the common sense of the English people would understand.

This recognition that truth to nature was not incompatible with aspirations to spirituality in classicizing art should have changed the direction and quality of classicizing art dramatically. To some degree it did, but the reception of the marbles in nineteenth-century Britain was probably as much as anything the response of a country which was the seat of empire and which regarded itself as a cultural leader, to the presence of works which bore witness to a society in which the western world sought its cultural roots. The superficial effect of the marbles, and especially of the frieze, was soon apparent and still is. The Henning family, for instance, created a small industry producing miniature versions of the frieze, in plaster, mounted in bound volumes. John Henning placed his version of the frieze on the exterior of the Athenaeum

in London, and he adapted it for a triumphal procession carved on the gateway at Hyde Park Corner, which gave on to that nineteenth-century expression of life viewed through myth, the bronze Achilles that celebrated the victories of Wellington. But all this is hardly more than the response of the Neoclassical tradition to a new source of inspiration, and examples can easily be multiplied.

The effect of the marbles on scholars was mixed. Some found it difficult to take them as originals at all. Others revised their views about what was Greek, and as more finds were made in Greece and Turkey (and many of them distributed to western museums) and as known works were reassessed, the marbles were able to contribute much to comprehension of the achievement, and to some degree even of the aims of the Classical artist. The search to understand them in terms of the society for which they were made continues to present a challenge to our views about the role of politics, religion and myth in Classical Athens. From the scholar's puzzlement, to public awe before the calm majesty of these colossal nudes and draped figures, to their significance to the heritage and national identity of Greece today, the Parthenon marbles will never relinquish their hold on our imaginations.

GLOSSARY

Capital The capital lies between the top of the column and the epistyle. Different styles of capital are a distinguishing feature of each Classical architectural order.

Entablature The whole assemblage of parts supported by the columns. The three primary divisions of the entablature are the epistyle, the frieze and (uppermost) the cornice.

Epistyle The lowest part of an entablature, this large piece of stone sits above the capitals and columns and below the frieze.

Frieze A large horizontal band of decorative stone that sits above the epistyle and below the cornice. A frieze of the Doric order normally consists of triglyphs and metopes.

Metope The square space between two triglyphs in a Doric frieze. Often left plain but sometimes featuring painted or sculptural decoration.

Pediment The triangular space created by the sloping eaves and horizontal cornice line of a gabled temple or other Classical building.

Porch A place for walking under shelter. The word is usually applied to the columned projection before the entrance to a temple or similar building.

Triglyph A feature of the frieze of the Doric order, consisting of a vertical element with two sunk vertical channels and two half-channels at the edges.

Definitions sourced from *The Classical Language of Architecture*, John Summerson, in the World of Art series, new edition published by Thames & Hudson in 2023.

LIST OF ILLUSTRATIONS

Measurements are given height before width, cm followed by inches

1. Attendants with cows for sacrifice (slab XL) in the south frieze. © David Finn Archive, Department of Image Collections, National Gallery of Art Library, Washington, DC. **2.** The Parthenon from the north-west. © David Finn. **3.** Head of Dionysos in the east pediment. © David Finn Archive, Department of Image Collections, National Gallery of Art Library, Washington, DC. **4.** Horse from Selene's chariot in the east pediment. © David Finn Archive, Department of Image Collections, National Gallery of Art Library, Washington, DC. **5.** Horsemen (slab X) in the south frieze. © David Finn Archive, Department of Image Collections, National Gallery of Art Library, Washington, DC. **6.** Horsemen (slab XIII) in the south frieze. © David Finn Archive, Department of Image Collections, National Gallery of Art Library, Washington, DC. **7.** Horsemen (slab XXXII) in the north frieze. © David Finn Archive, Department of Image Collections, National Gallery of Art Library, Washington, DC. **8.** Horseman (slab X) in the south frieze. © David Finn Archive, Department of Image Collections, National Gallery of Art Library, Washington, DC. **9.** Athenian hero (slab IV) in the east frieze. © David Finn Archive, Department of Image Collections, National Gallery of Art Library, Washington, DC. **10.** Athenian heroes (slab IV) in the east frieze. © David Finn Archive, Department of Image Collections, National Gallery of Art Library, Washington, DC. **11.** Attendants with cows for sacrifice (slab XL) in the south frieze. © David Finn Archive, Department of Image Collections, National Gallery of Art Library, Washington, DC. **12.** Centaur and youth on south metope 31. © David Finn Archive, Department of Image Collections, National Gallery of Art Library, Washington, DC. **13.** Detail of centaur on south metope 31. © David Finn Archive, Department of Image Collections, National Gallery of Art Library, Washington, DC. **14.** Detail of youth on south metope 30. © David Finn Archive, Department of Image Collections, National Gallery of Art Library, Washington, DC. **15.** Centaur and youth on south metope 2. © David Finn Archive, Department of Image Collections, National Gallery of Art Library, Washington, DC.

ALSO AVAILABLE IN THE
POCKET PERSPECTIVES SERIES:

Be the first to know about our new releases,
exclusive content and author events by visiting
thamesandhudson.com
thamesandhudsonusa.com
thamesandhudson.com.au

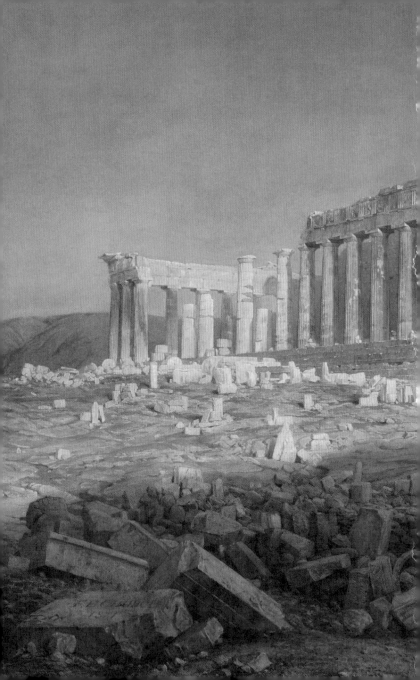